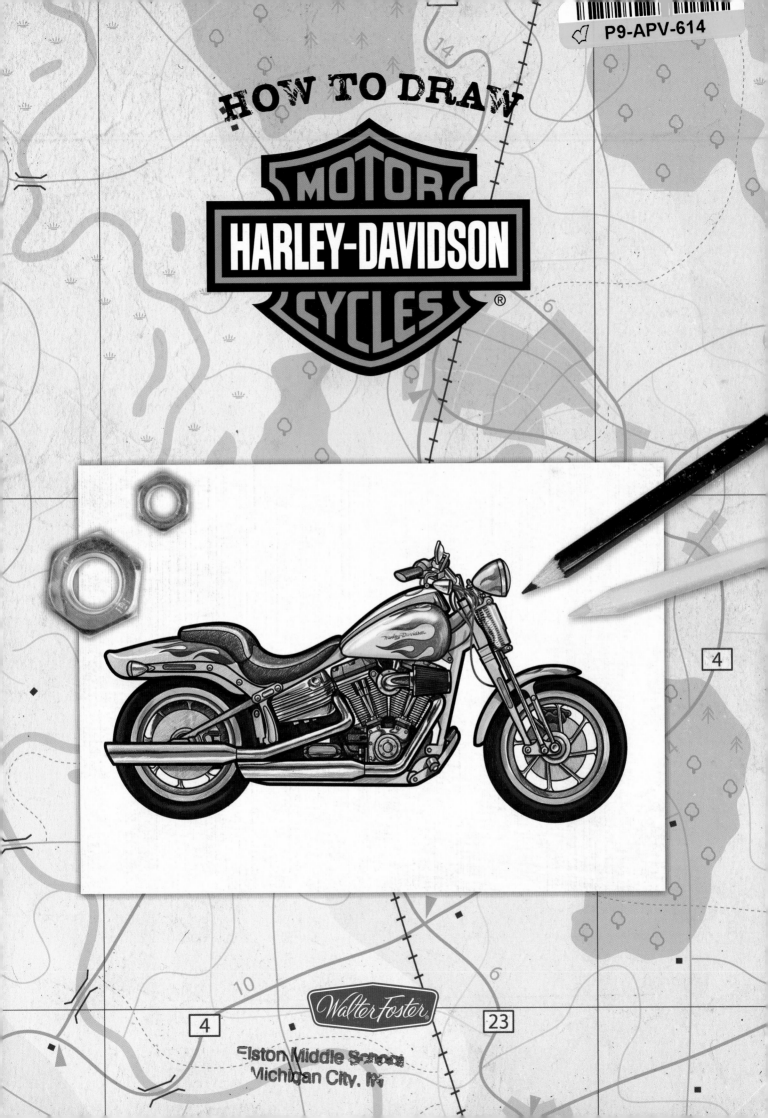

Illustrated by Tom LaPadula
Written by Jickie Torres

Project Editor: Rebecca J. Razo
Art Director/Designer: Shelley Baugh
Production Artist: Debbie Aiken
Production Manager: Nicole Szawlowski

www.walterfoster.com
3 Wrigley, Suite A
Irvine, CA 92618

1 3 5 7 9 10 8 6 4 2

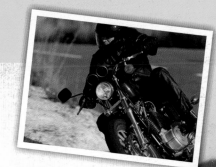

Table of Contents

History of Harley-Davidson®

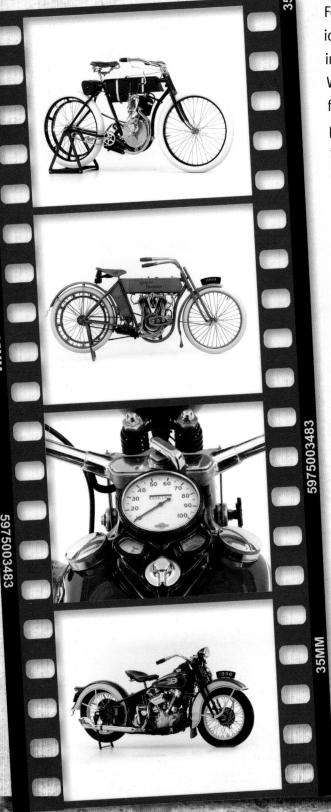

Few American landmarks have stood longer than the iconic Harley-Davidson® motorcycle. It all started in 1901 in Milwaukee, Wisconsin, when 21-year-old William S. Harley, inspired by his work at a bicycle factory, envisioned something greater: a bicycle powered by an engine. He joined forces with his friend Arthur Davidson and for the next two years, the young men worked out of a humble 10- by 15-foot backyard shed, laboring over a motor that would fit into a regular pedal-bicycle frame. It wasn't long before Arthur's brother Walter joined the team and, in 1903, the group completed the project. However, the first engine-mounted bicycle wasn't quite the success the men had anticipated. The motor wasn't powerful enough on its own to take even the small hills around the neighborhood without the aid of manual peddling. Undeterred, the men persevered.

The group built a second bike with bigger flywheels and an engine more than three times the original size. Another Davidson brother, William, who at the time worked for the West Milwaukee Railshops, supplied tools and helped manufacture special parts. Using a new loop frame design for the production bike, the second motor was more akin to an automobile's specifications than to a motor-bicycle's specifications. The team knew the project was a success when their motorcycle finished fourth in a motor race at the Milwaukee State Fair. The men sold their

prototype to a friend, and the same shed where one Harley and three Davidsons roughly scrawled "Harley-Davidson Motor Company" on the front door three years earlier soon became a legitimate place of business.

The Harley-Davidson Motor Company was growing fast. By 1904, a Chicago dealership was selling some of the first Harley-Davidson motorcycles. A year later, the team entered a motorcycle into a 15-mile race—it won first place.

Success continued at top speed as the Harley-Davidson Motor Company expanded by adding new employees and larger factories, and subsequently publishing a catalog that showcased its unique brand of motorcycle to dealers across the East Coast. By 1909, six years after the birth of the Harley-Davidson Motor Company, the team had produced its first V-twin engine: a 49.5 cubic-inch, seven horsepower motor with two cylinders in a 45-degree configuration. Today, the V-twin is considered the classic American motorcycle engine.

Harley-Davidson motorcycles were quickly attaining distinction and status in American history. In addition to winning races and competing in automobile shows, law enforcement agencies began purchasing and using the company's motorcycles in their fleets. Later, in 1917 with the start of World War I, the motorcycles were drafted for use as combat vehicles—an effort that also was important to the company's founders. Within a year, about half of all Harley-Davidson motorcycles were being created specifically for the military. The company even started a school to train soldiers on the repair and maintenance of the motorcycles.

(Continued on page 6)

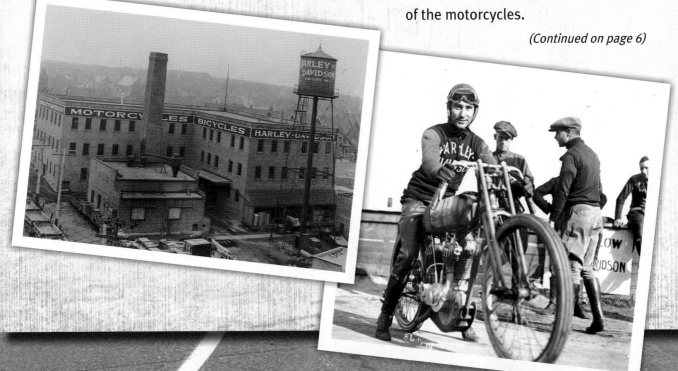

History of Harley-Davidson®

Even after the war, the need for speed never ended. Harley-Davidson continued to create new, more powerful engines, such as the 45 cubic-inch "Flathead." In the 1920s, the Harley-Davidson Motor Company saw the breaking of land-speed records and growing sales internationally. Soon, it was the world's largest motorcycle manufacturer. In 1936, the EL Model debuted sporting a new engine later nicknamed the "Knucklehead" for the shape of its cylinder heads. Harley-Davidson riders began forming motorcycle clubs and race teams, and the motorcycles helped riders win championships like the AMA Grand Nationals and the Daytona 200. In the decades that followed, the trend continued, as Harley enlisted its bikes once again for World War II, continued to invent new models, defeated records, and inspired American dreams.

For the Harley-Davidson Motor Company, it's not the destination—it's the journey. And this journey has been filled with racing legends, community service, revolutionary designs, and inspirational moments throughout history. What started as an adventure on two wheels, a motor, a seat, and a handlebar grew into an American legend. Today, the Harley-Davidson Motor Company continues to deliver high-power, high-quality bikes that push the envelope of design and expectation.

Parts of a Motorcycle

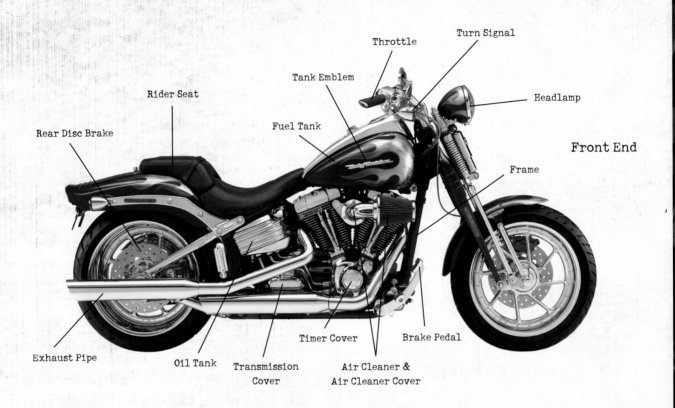

Rider Seat

Rear Disc Brake

Tank Emblem

Throttle

Turn Signal

Headlamp

Fuel Tank

Front End

Frame

Exhaust Pipe

Oil Tank

Transmission Cover

Timer Cover

Air Cleaner & Air Cleaner Cover

Brake Pedal

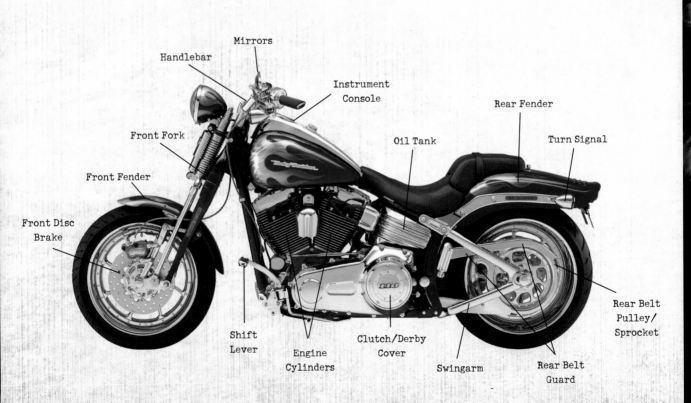

Mirrors

Handlebar

Instrument Console

Rear Fender

Front Fork

Oil Tank

Turn Signal

Front Fender

Front Disc Brake

Shift Lever

Engine Cylinders

Clutch/Derby Cover

Swingarm

Rear Belt Guard

Rear Belt Pulley/ Sprocket

Tools & Materials

You'll need only a few simple supplies to draw Harley-Davidson motorcycles. You may prefer working with a drawing pencil to begin with, and it's always a good idea to have a pencil sharpener and an eraser nearby. When you've finished drawing, you can add color with felt-tip markers, colored pencils, watercolors, or acrylic paint. The choice is yours!

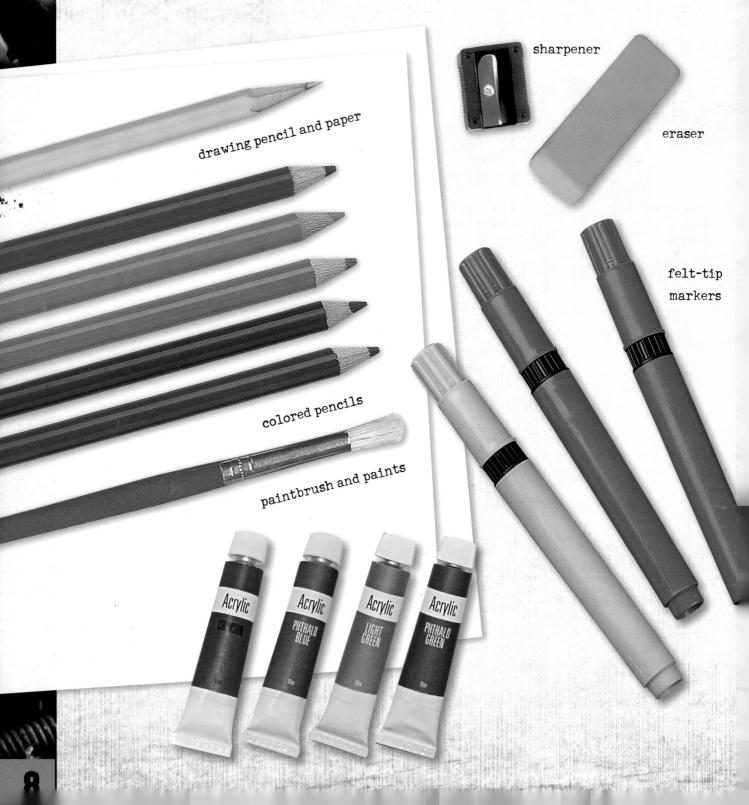

drawing pencil and paper

sharpener

eraser

felt-tip markers

colored pencils

paintbrush and paints

Acrylic CRIMSON

Acrylic PHTHALO BLUE

Acrylic LIGHT GREEN

Acrylic PHTHALO GREEN

How to Use This Book

This book will show you how to draw Harley-Davidson motorcycles in just a few simple steps. With a little practice, you'll soon be producing successful drawings of your own!

1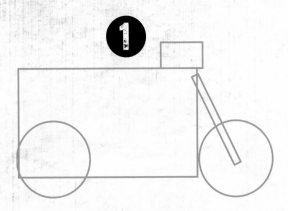

First draw the basic shapes using light lines that will be easy to erase.

2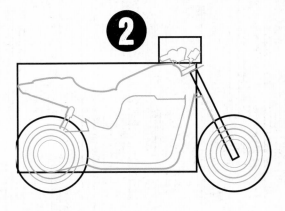

Each new step is shown in blue, so you'll know what to add next.

3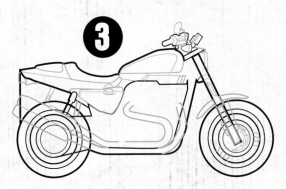

Follow the blue lines to draw the details.

4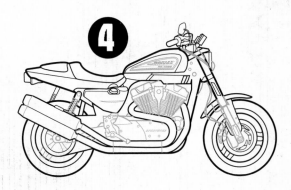

Darken the lines you want to keep, and erase the rest.

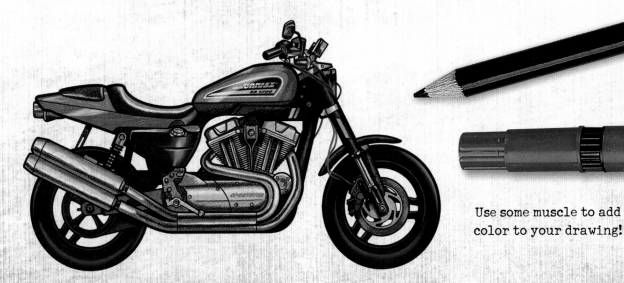

Use some muscle to add color to your drawing!

1954 Model KH

The thrilling model KH delivered surging power from a newly engineered 55 cubic-inch engine. Fueled by customers who wanted more power, Harley-Davidson ramped up speed for this model. Like each of the bikes released during the company's 50th anniversary year, the KH boasted a special medallion mounted to the front fender.

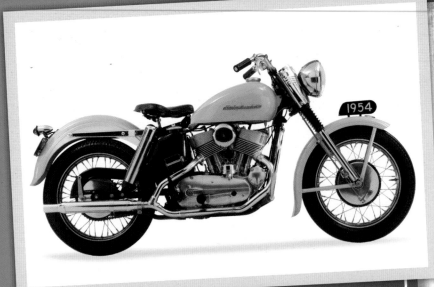

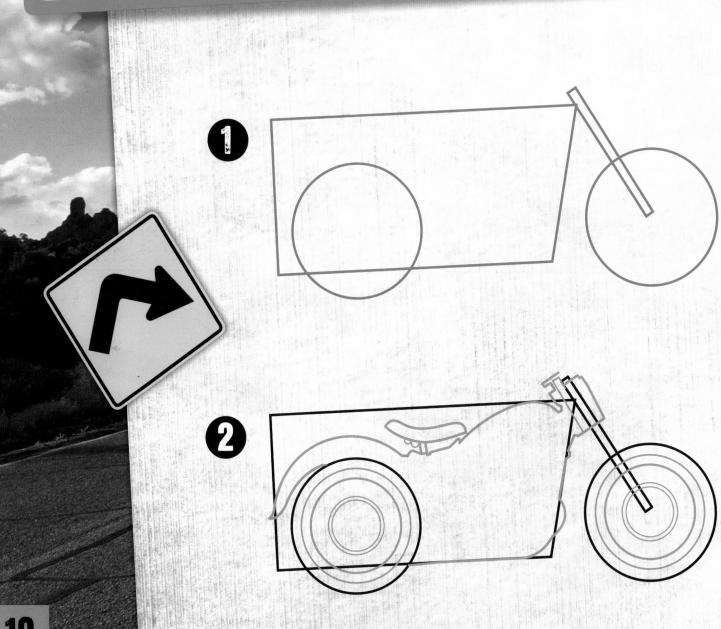

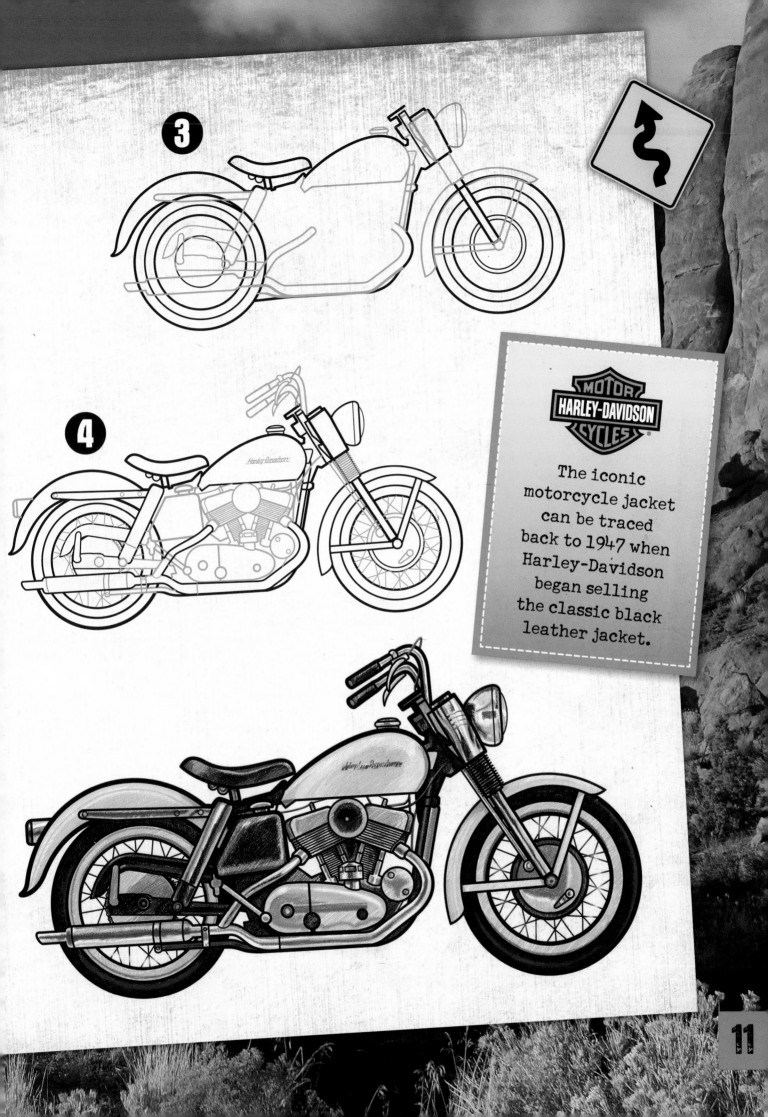

3

4

1968 FLHFB Electra Glide®

Full of power and ready to rule the road, the FLHFB Electra Glide was the king of heavyweight touring bikes. A dual saddle for comfort and a top luggage rack made this motorcycle perfect for long rides, and the premium suspension provided a smooth ride.

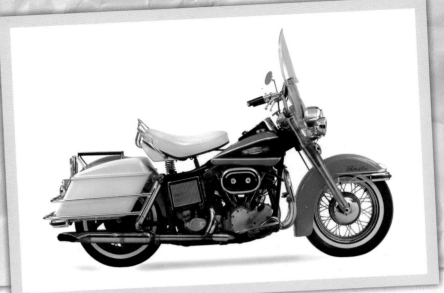

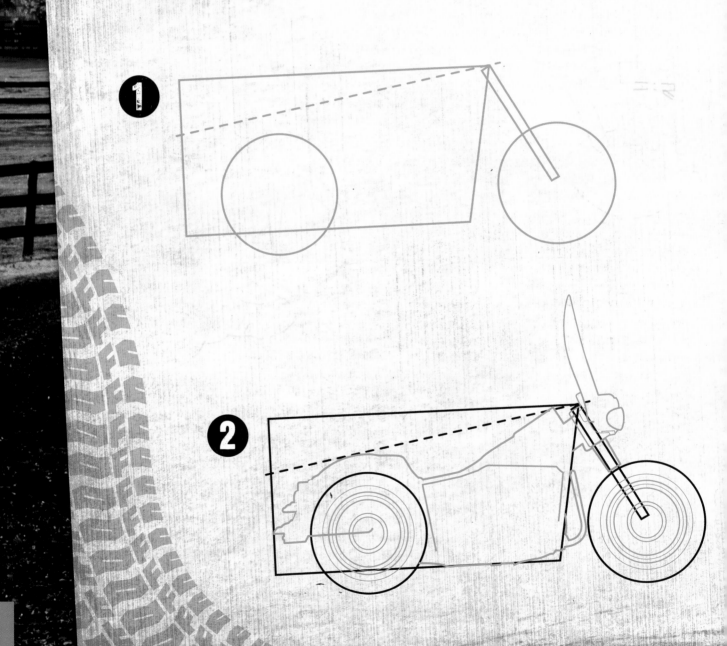

1

2

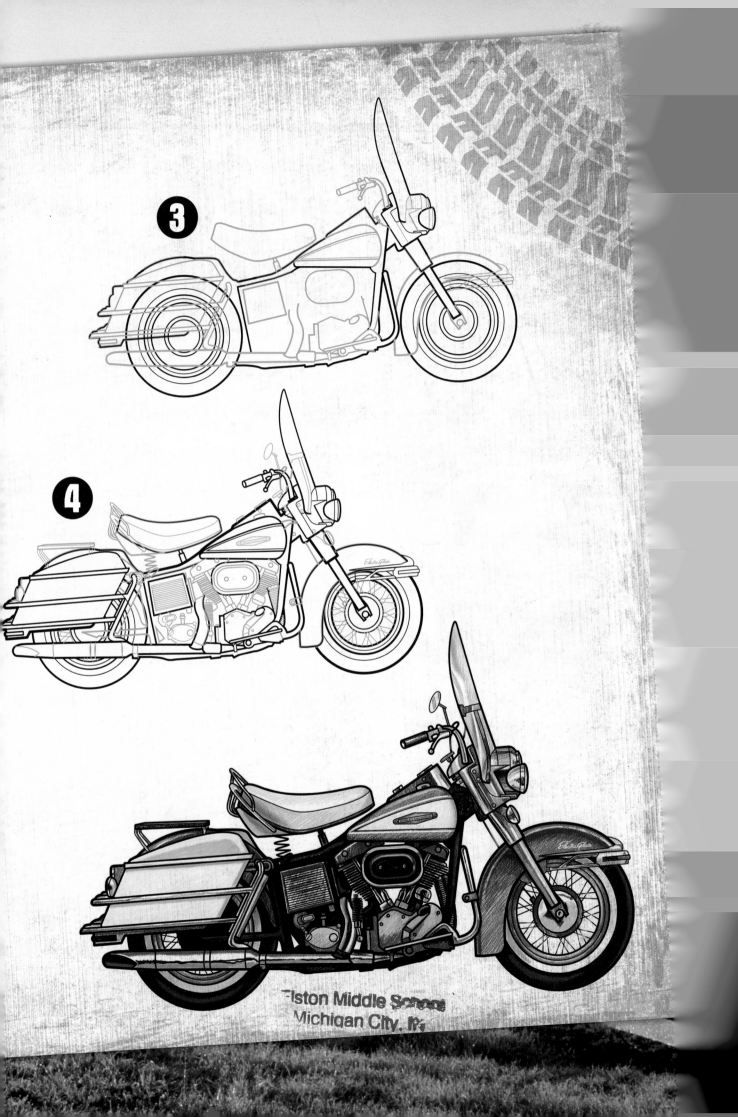

Elston Middle School
Michigan City, IN

1979 XL-1000 Sportster®

Sporting a new triangulated frame, the XL-1000 was an exciting revolution to a model that had been in the Harley-Davidson family for 22 years. The new design also hid the battery and oil tank with painted body covers, used a new "Ham Can" air cleaner, and sported a new Siamese exhaust configuration.

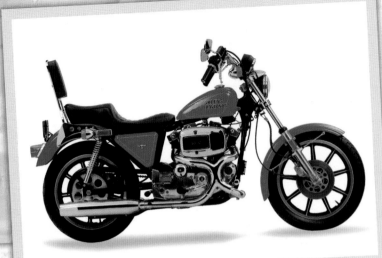

1

2

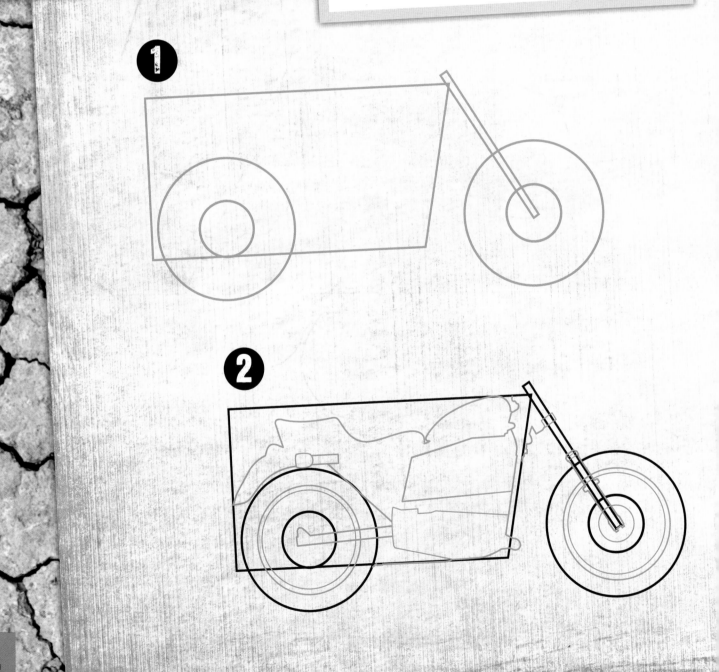

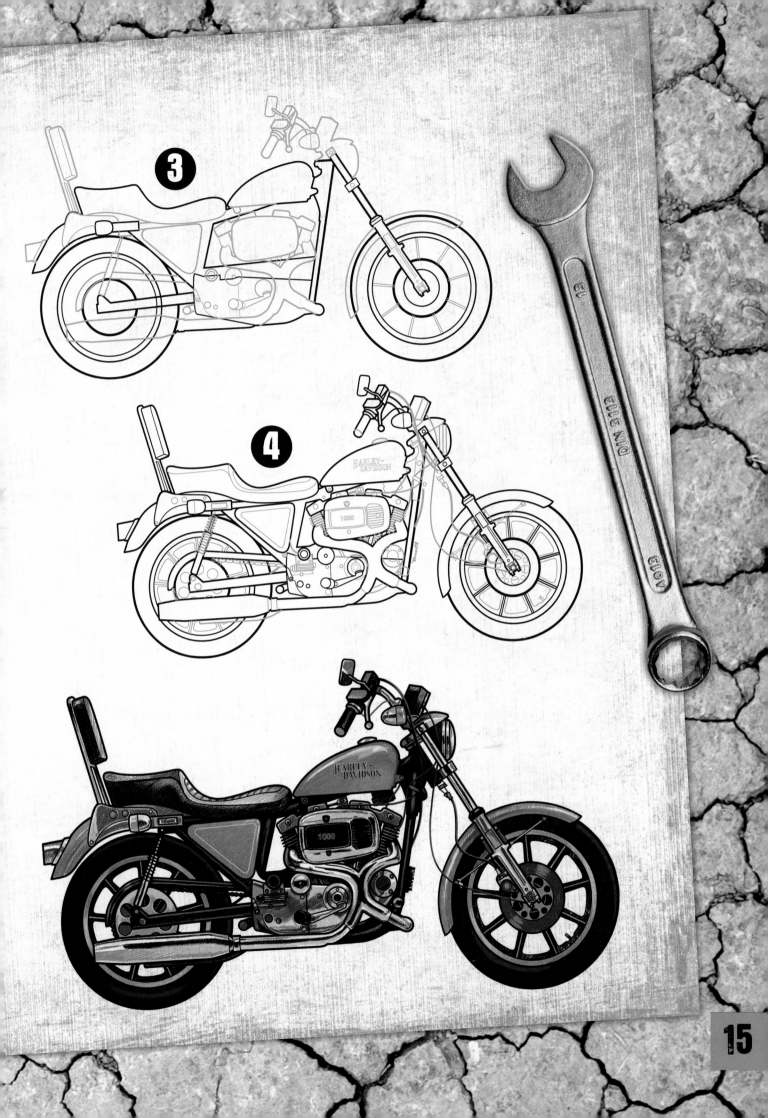

1984 FXST Softail®

From 1957 until 1984, Harley-Davidson motorcycles traditionally had visible rear shock absorbers. That all changed with the invention of the Softail, a motorcycle that hid the rear shock absorbers for a more classic "hardtail" look.

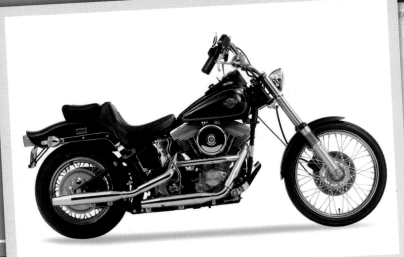

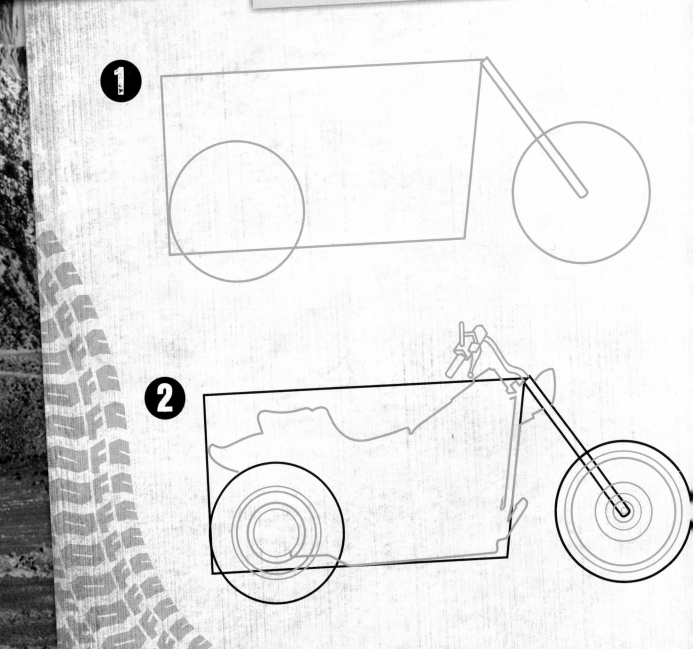

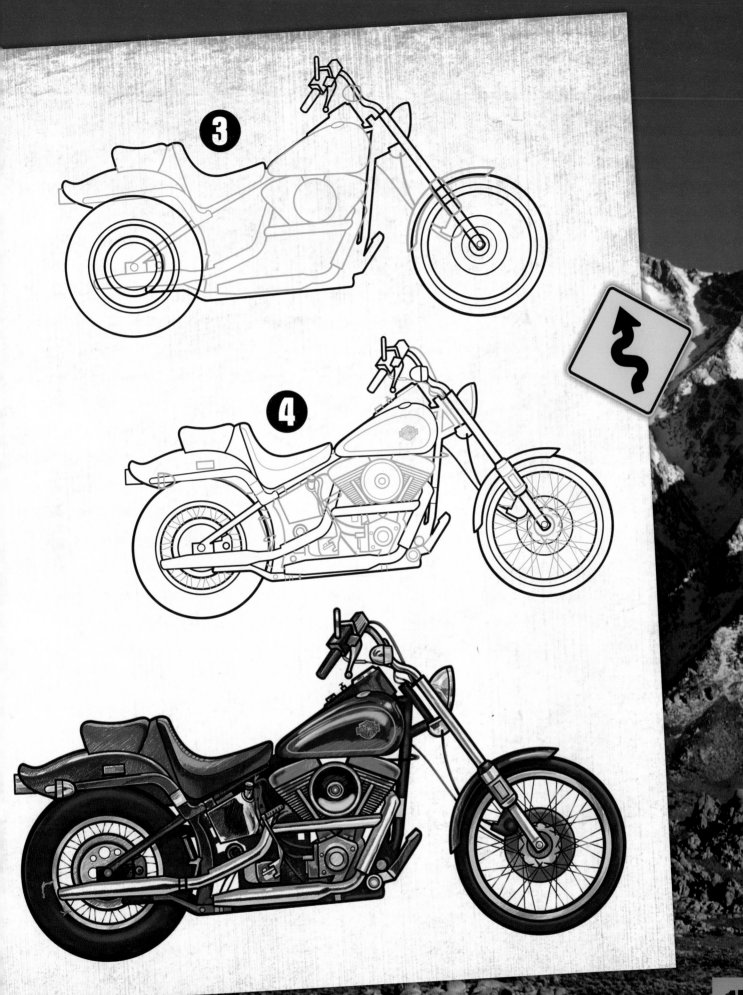

1999 FXR²

Special paint schemes, unique accessories, and a personalized ride—that's what Harley-Davidson created when it began producing a line of limited-production motorcycles for the Custom Vehicle Operations (CVO) program. Only 900 units of this model were manufactured.

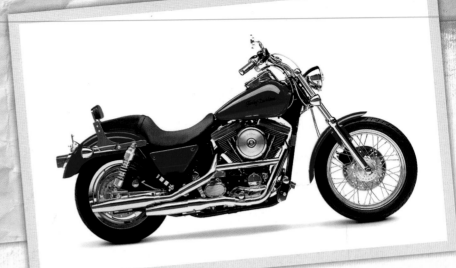

1

POST CARD
THIS SPACE FOR WRITING MESSAGES.
THIS SPACE FOR ADDRESS ONLY.
PLACE STAMP HERE

Declare your independence!

2

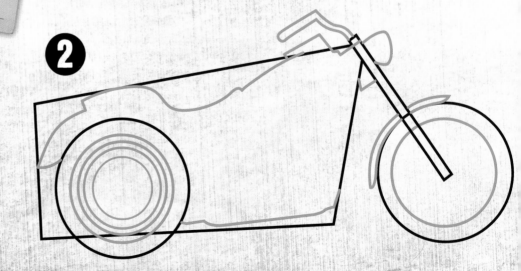

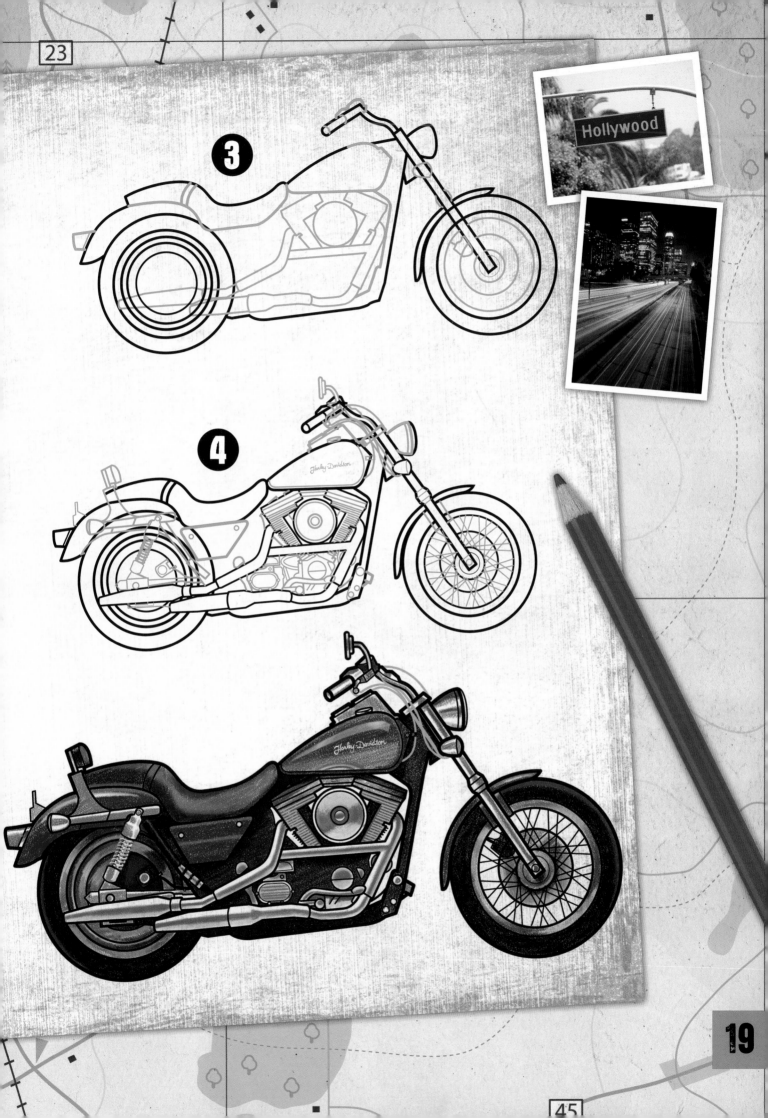

Hollywood

2006 Firefighter Special Edition Road King®

Created especially for firefighters, the 2006 Special Edition Road King features fire-engine-red paint and firefighter graphics. This motorcycle continues the Harley-Davidson tradition of strong reliable touring bikes and the company's commitment to supporting and honoring our nation's heroes.

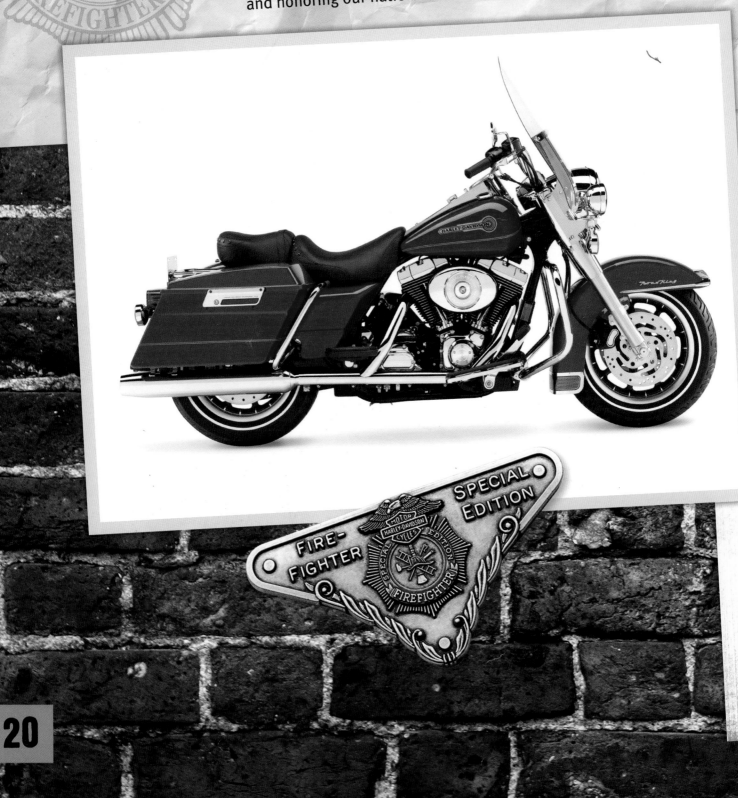

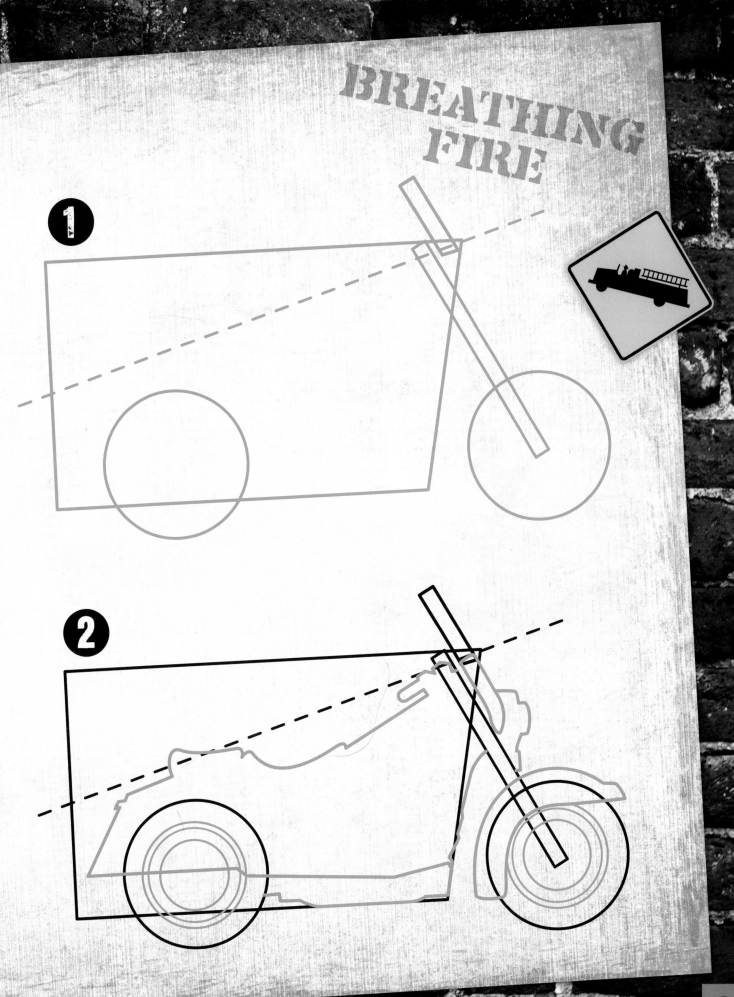

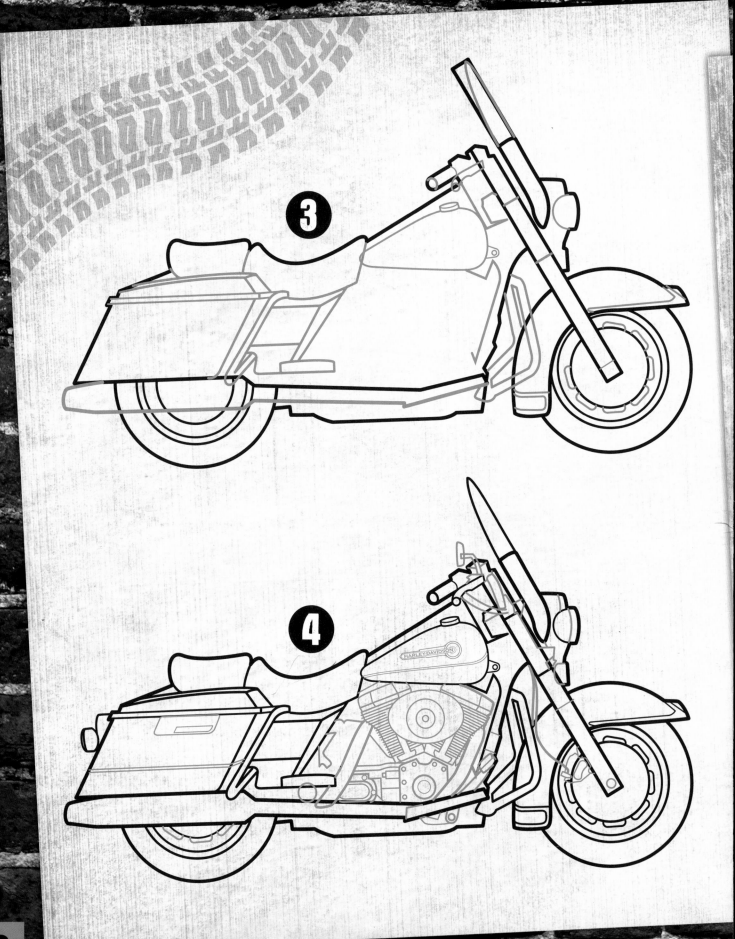

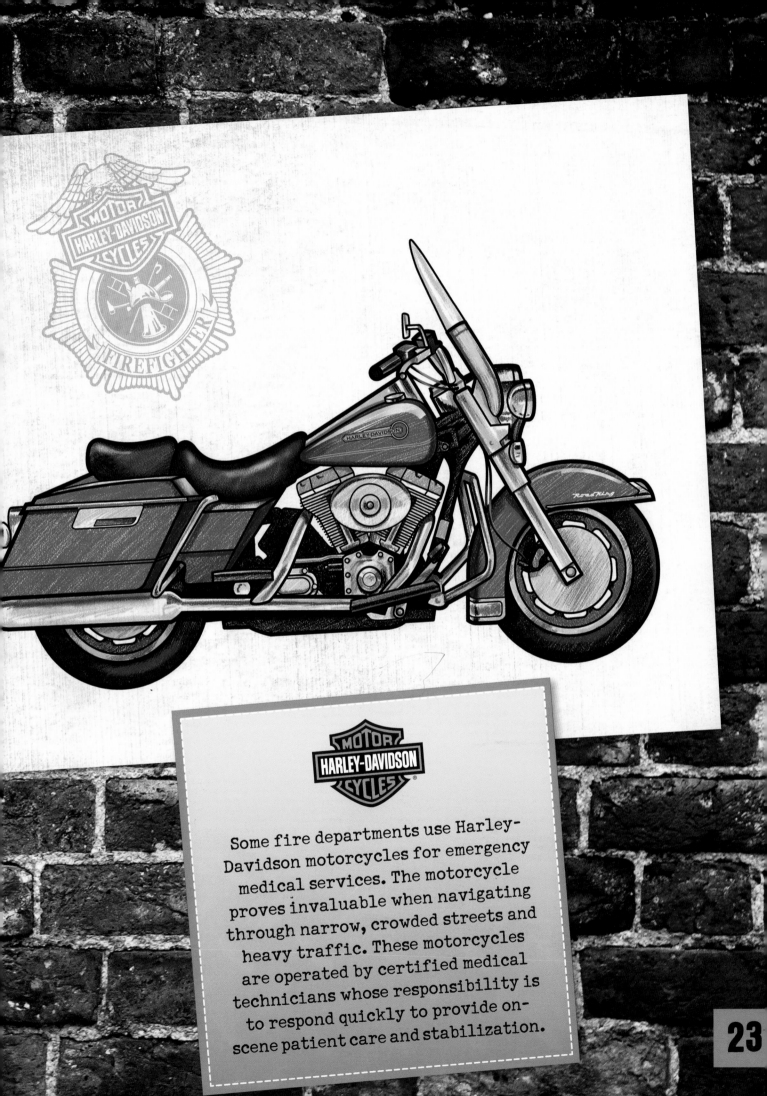

Some fire departments use Harley-Davidson motorcycles for emergency medical services. The motorcycle proves invaluable when navigating through narrow, crowded streets and heavy traffic. These motorcycles are operated by certified medical technicians whose responsibility is to respond quickly to provide on-scene patient care and stabilization.

2009 FLHP Emergency Police Road King®

Since 1908, Harley-Davidson has been helping police officers protect and serve with modernized specialty motorcycles. For the 2009 Police Road King, a new chassis delivers sharper handling, more load-bearing power, and an even more comfortable ride.

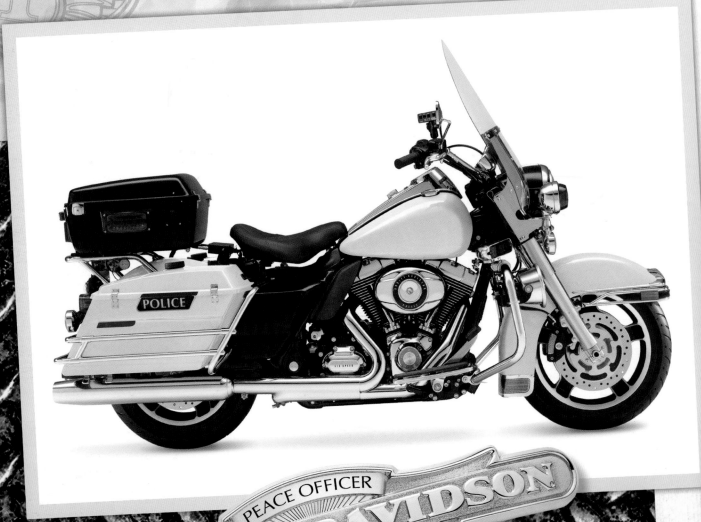

PEACE OFFICER

HARLEY-DAVIDSON

SPECIAL EDITION

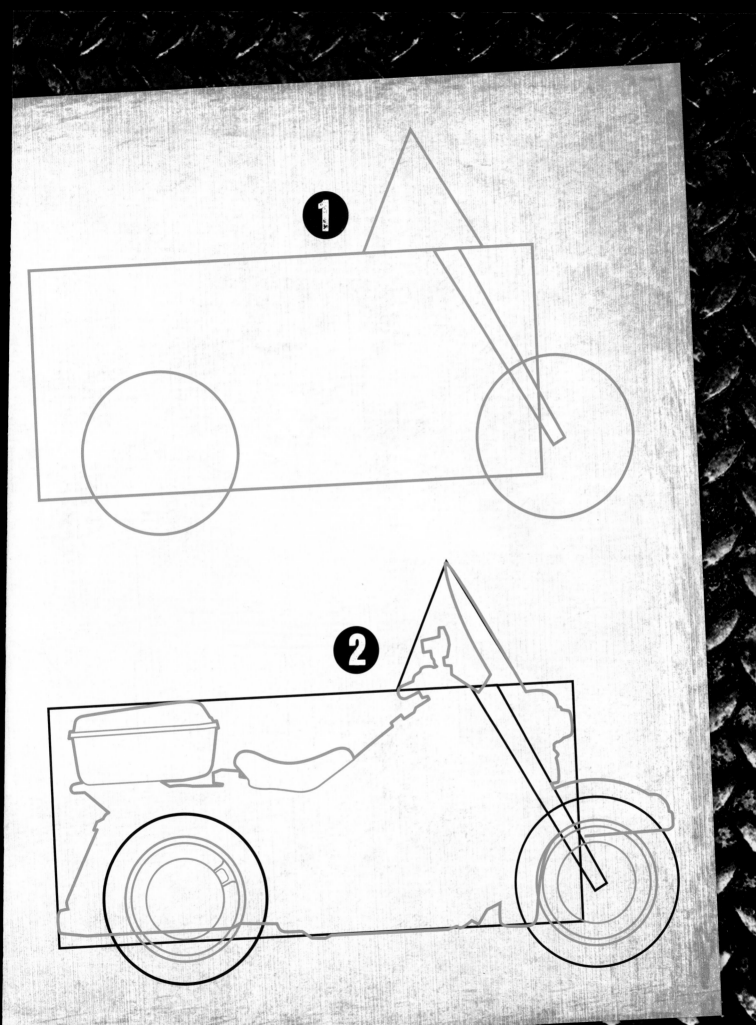

MORE THAN A MACHINE

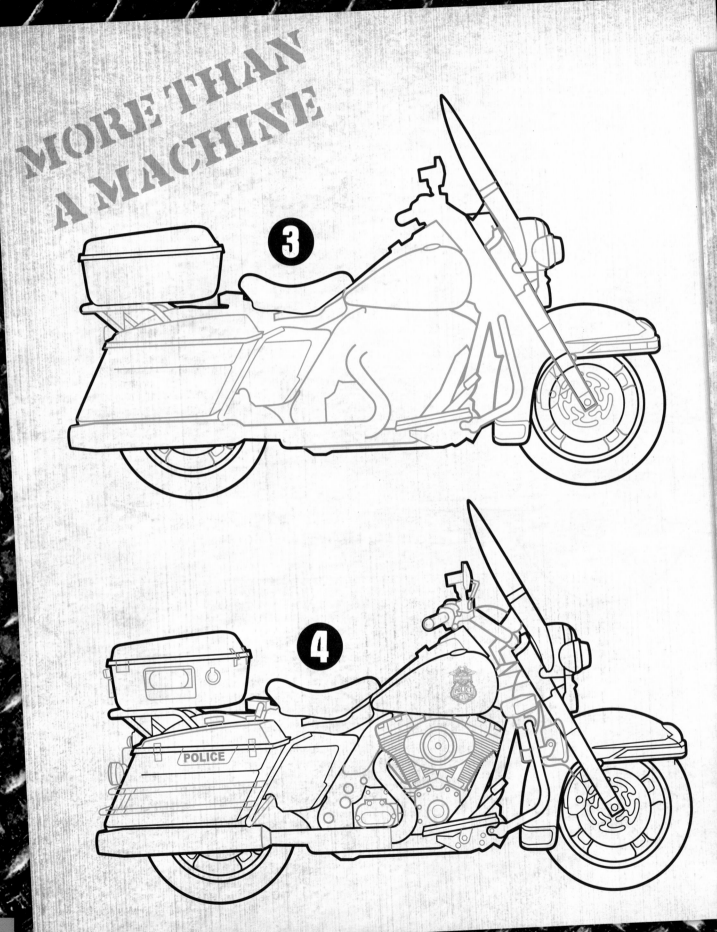

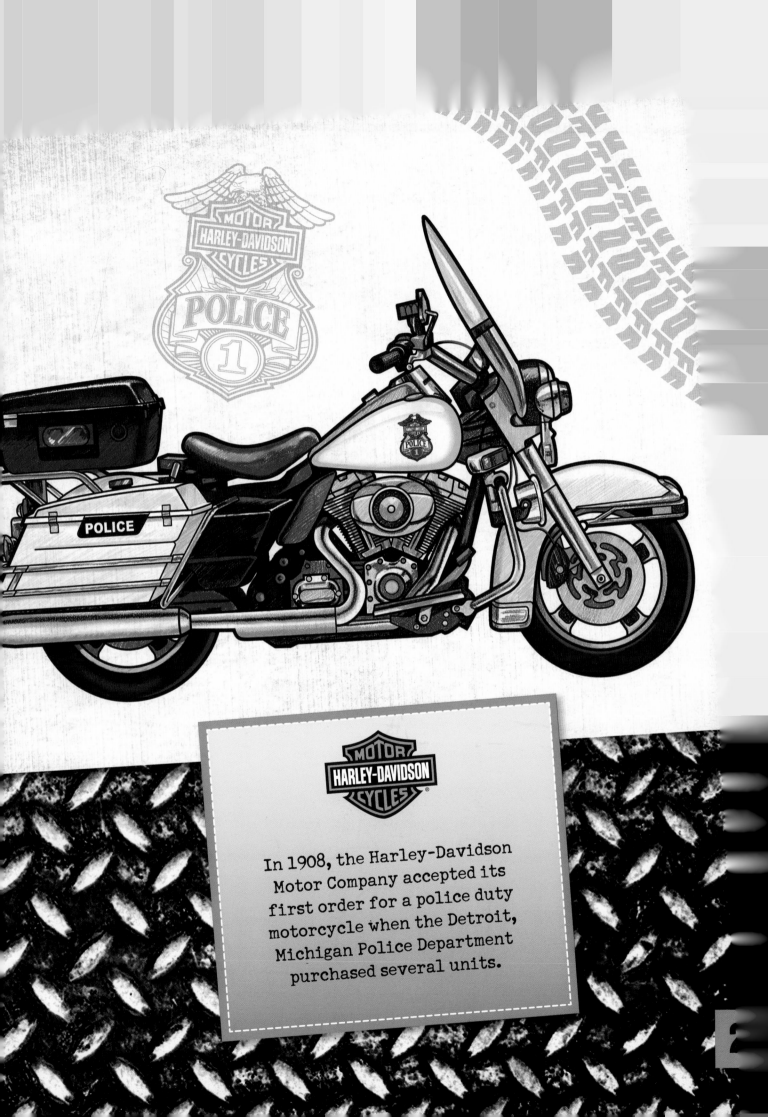

In 1908, the Harley-Davidson Motor Company accepted its first order for a police duty motorcycle when the Detroit, Michigan Police Department purchased several units.

2004 FLHTCSE Screamin' Eagle® Electra Glide®

What makes this custom ride so special is an oil-cooled 103 cubic-inch "stroker" engine, sporting plenty of custom details. It gives the smooth touring motorcycle outstanding power.

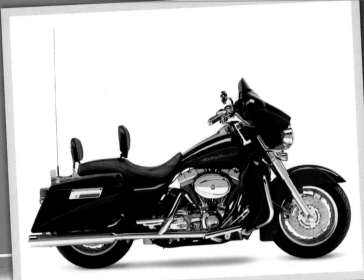

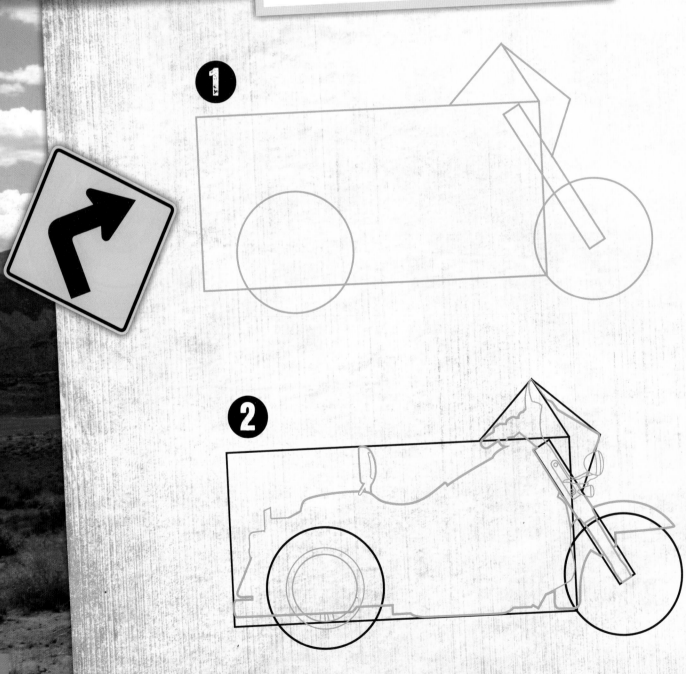

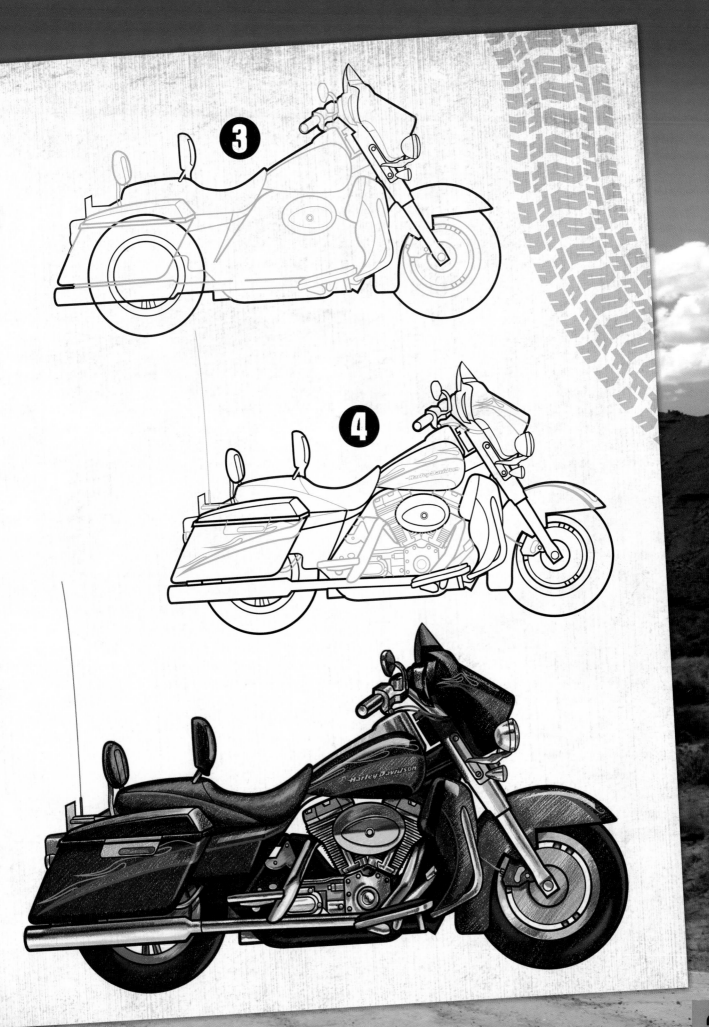

2006 V-Rod® Destroyer

Start your engine! The pro-performance Destroyer is a lean, mean, competitive drag-racing machine. The Custom Vehicle Operations program designed the Destroyer with a 1300cc engine, pushbutton shifting, high-compression pistons, high-strength cylinders, and high-flow heads that equal extreme speed and winning power. The Destroyer is for racing only; you'll never see one at a stop light!

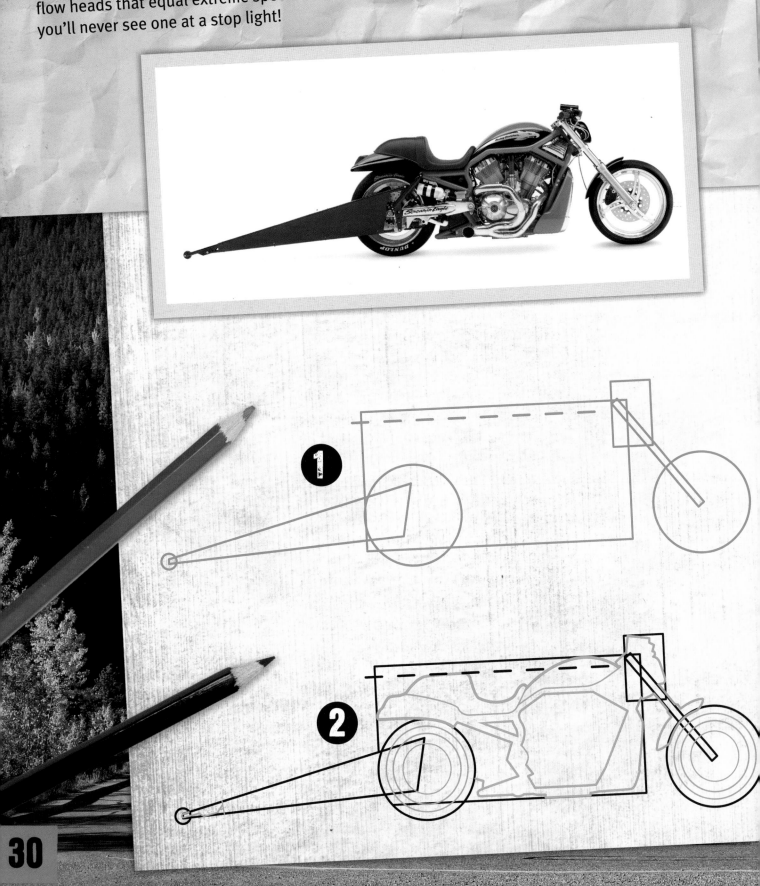

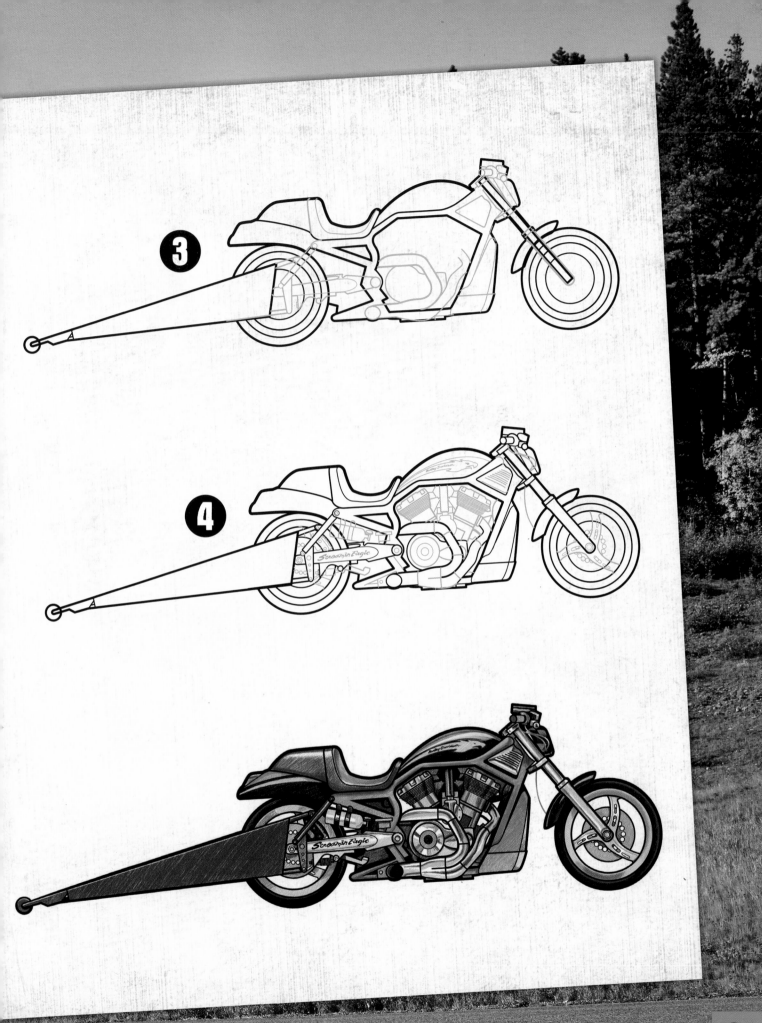

2008 FXCW Rocker™

Steel, rubber, leather, and chrome have never been so custom cool. The Rocker revolutionized radical custom Harley-Davidson motorcycles with its long-bike proportions and dramatic new shape. For the Rocker, the wheelbase was stretched to 69.2 inches versus the traditional 66.9 inches of the Softail.

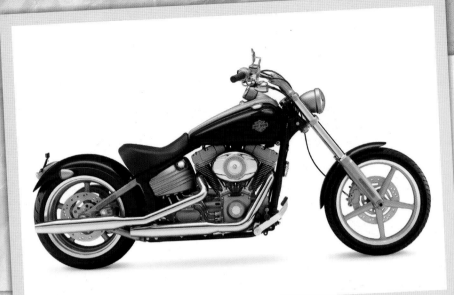

1

2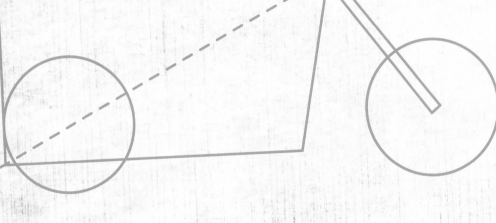

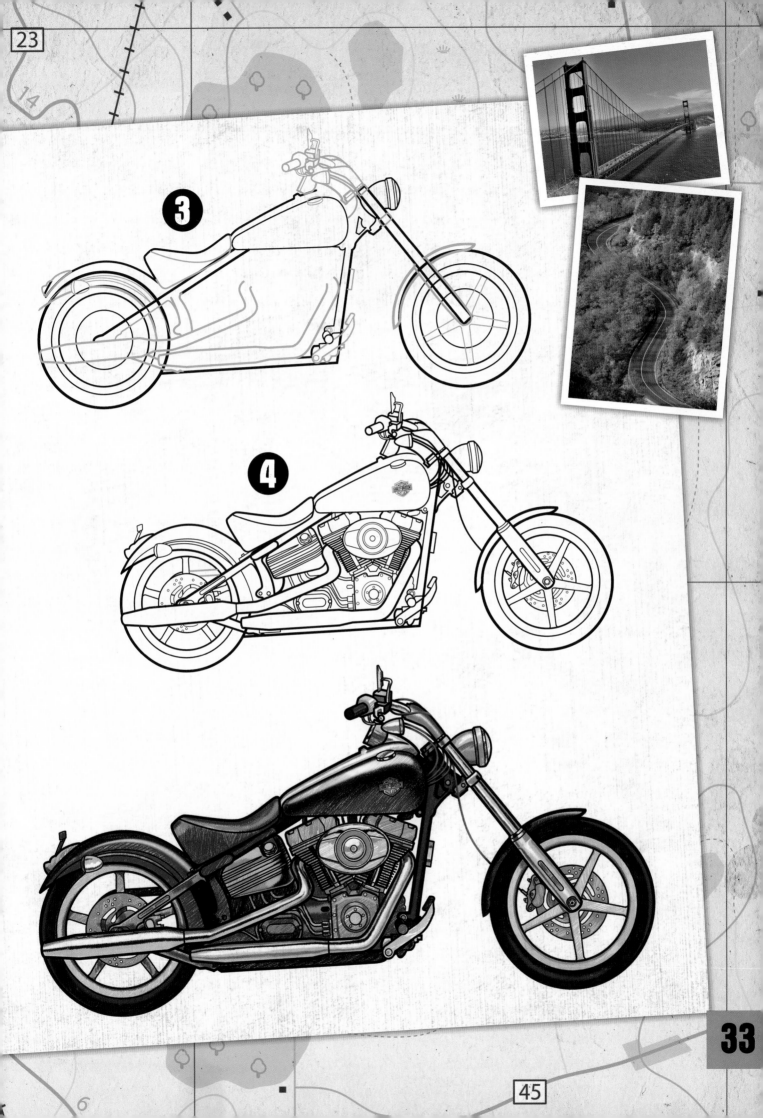

2009 Sportster® XR1200™

Harley-Davidson gets back to classic sport-bike basics with the XR1200. Its narrow, nimble frame packs light but rides big with the help of a high torque silver powder-coated 1200cc Evolution engine and inverted forks.

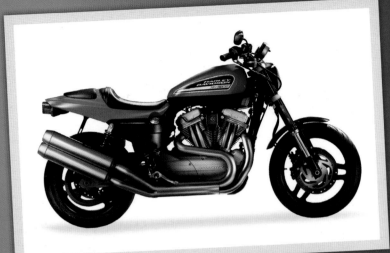

1

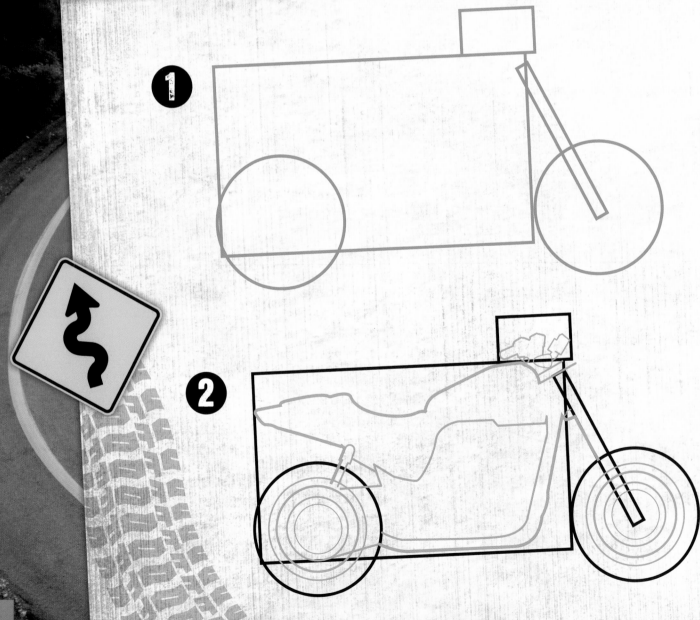

2

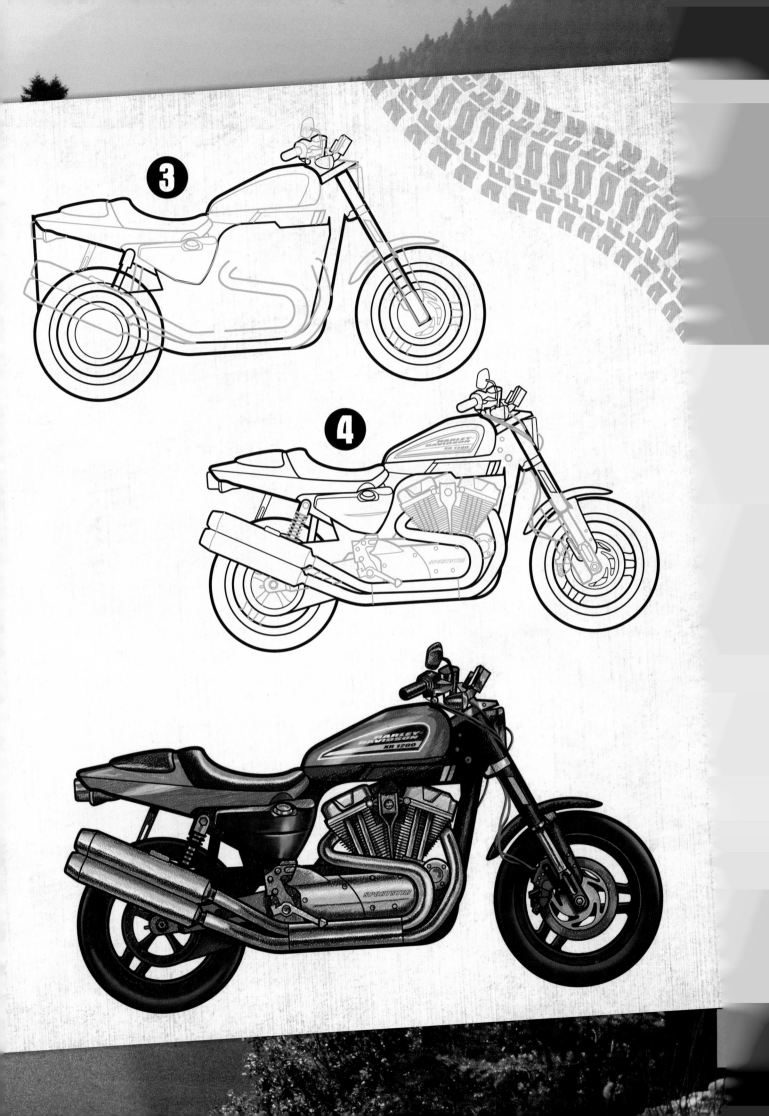

2009 CVO™ Softail® Springer®

Since 1999, when Harley-Davidson introduced the Custom Vehicle Operations (CVO) program, custom motorcycles haven't been the same. Each CVO model features unique paint schemes and accessories, creating demand that far exceeds production.

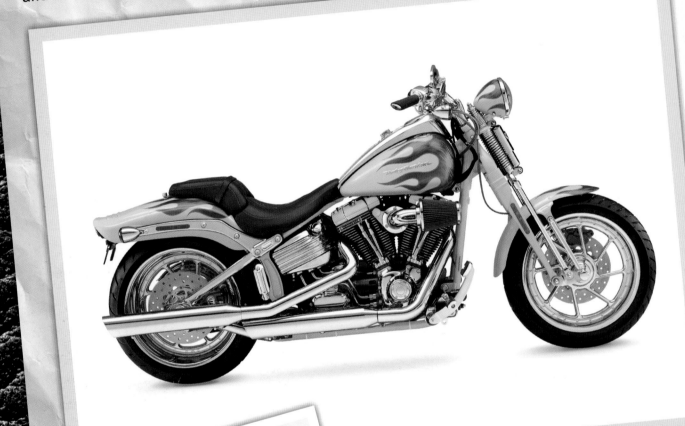

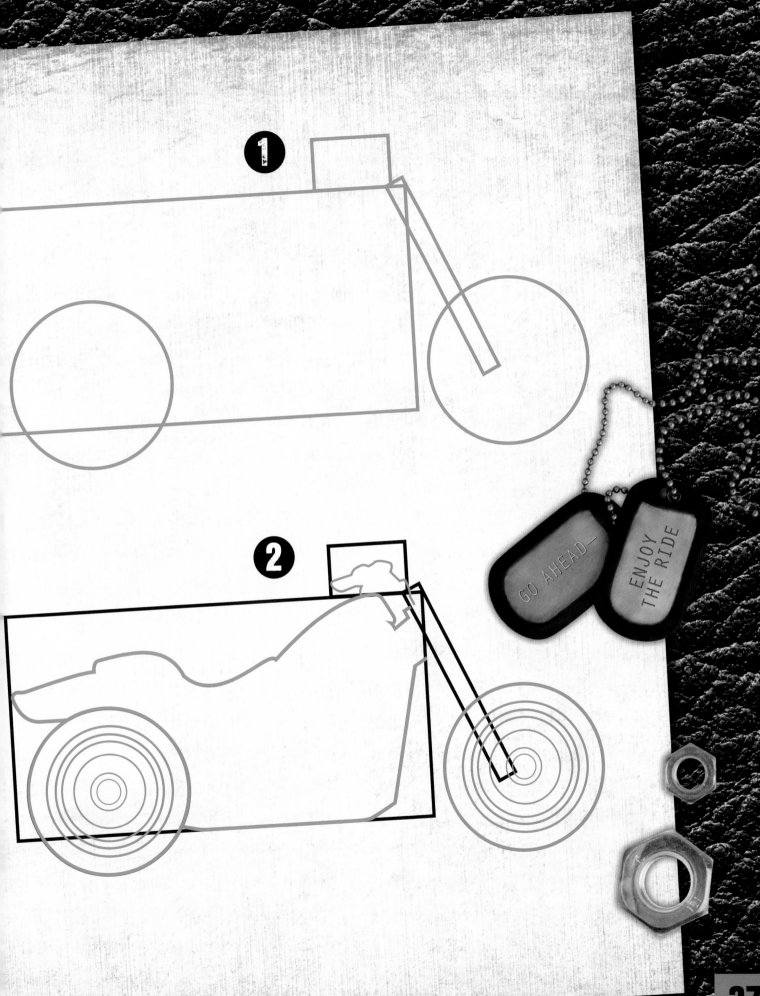

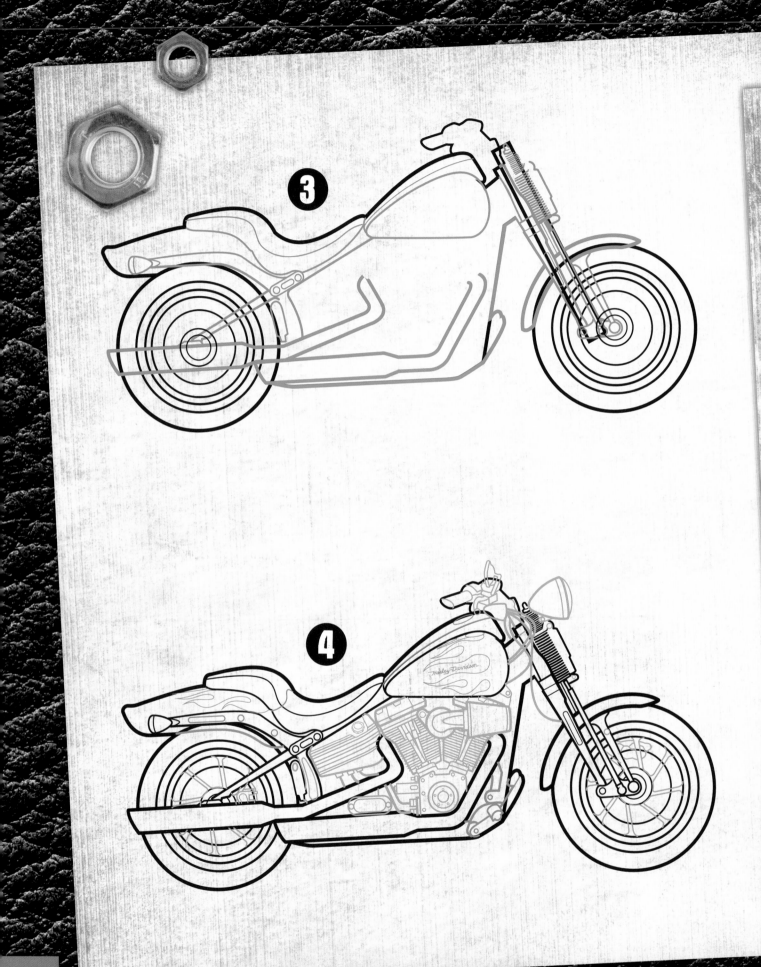

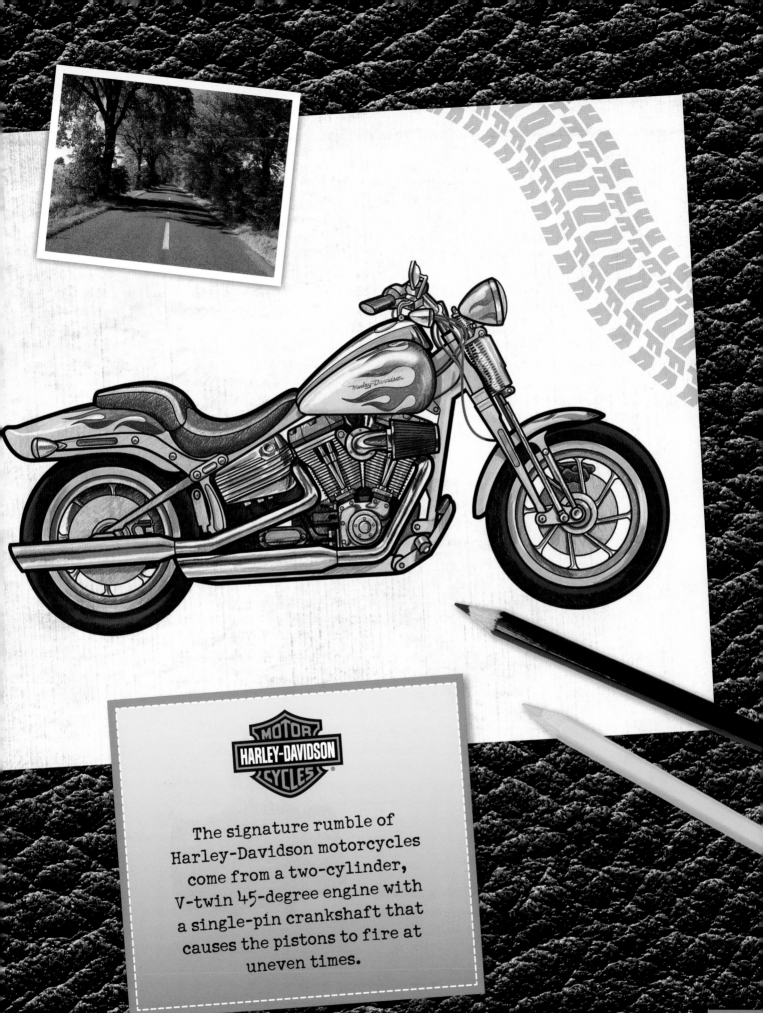

The signature rumble of Harley-Davidson motorcycles come from a two-cylinder, V-twin 45-degree engine with a single-pin crankshaft that causes the pistons to fire at uneven times.

2010 Street Glide® Trike

Built for maximized handling, the Street Glide Trike hits the road with three-wheel power. Like all Street Glides, the Trike is a smooth touring vehicle with a sleek, low, and lean profile; however, a new lengthened front fork ensures this Trike drives like a dream.

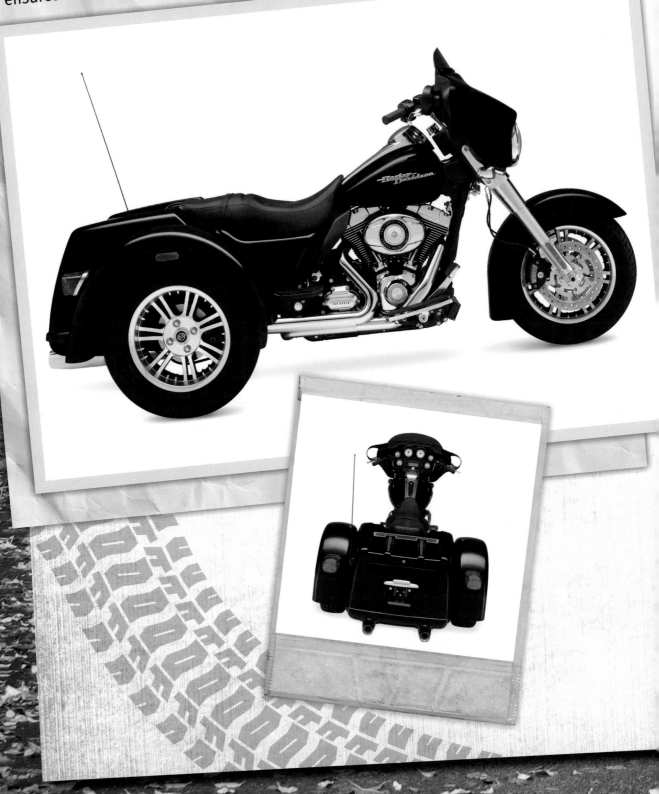

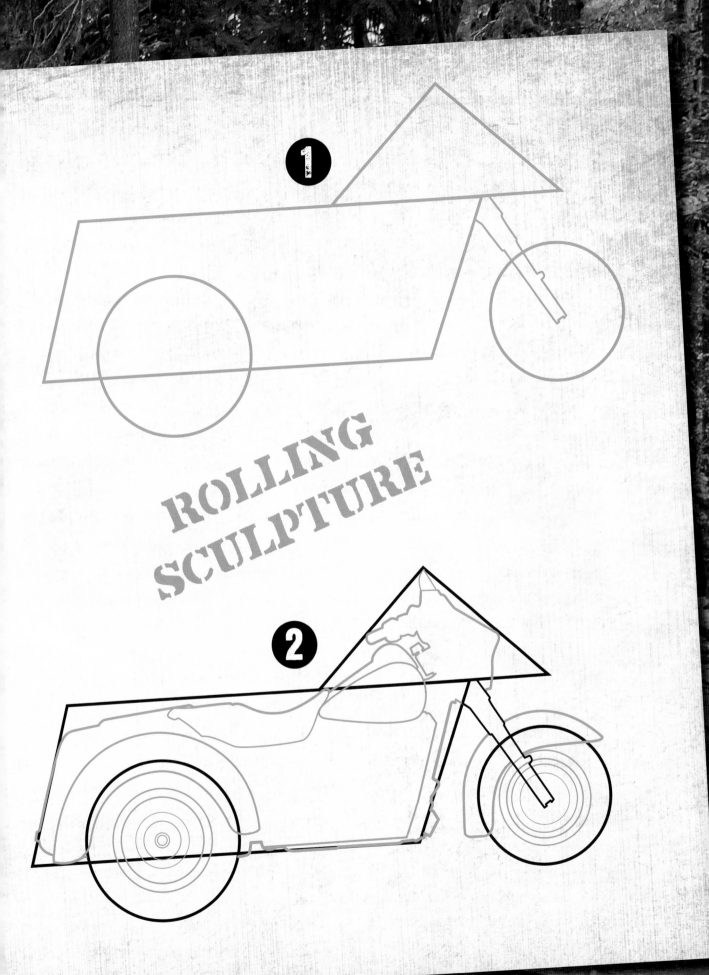

ROLLING SCULPTURE

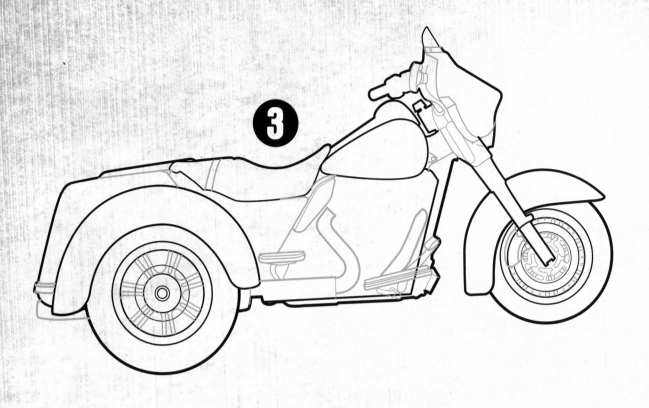

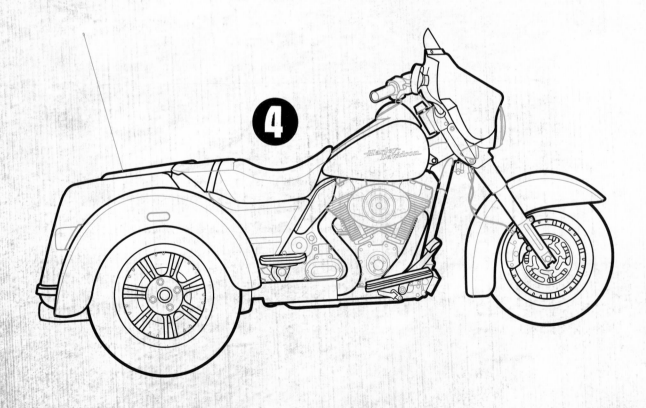

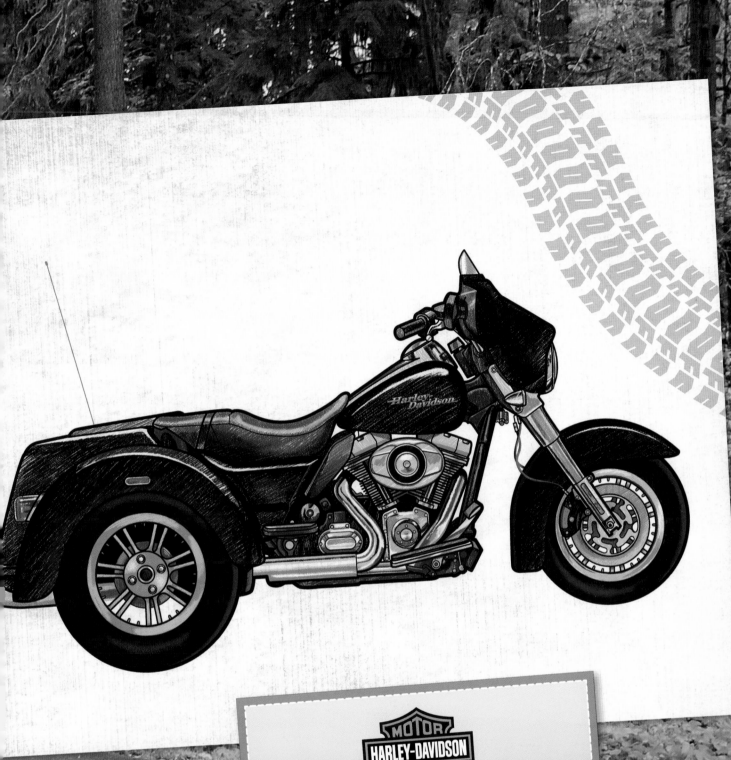

The classic teardrop-shaped
gas tank was introduced
in 1925, and the style has
become the basic shape
for most Harley-Davidson
motorcycles ever since.

2010 Softail® Cross Bones™

A new addition to the Softail family, the Cross Bones is more than a machine—it's a statement. The 2010 Cross Bones packs a timeless punch with its pared-down, simple style. A Springer front end keeps the drive smooth, and the mini "Ape-Hanger" handlebars keep the driver upright and in control.

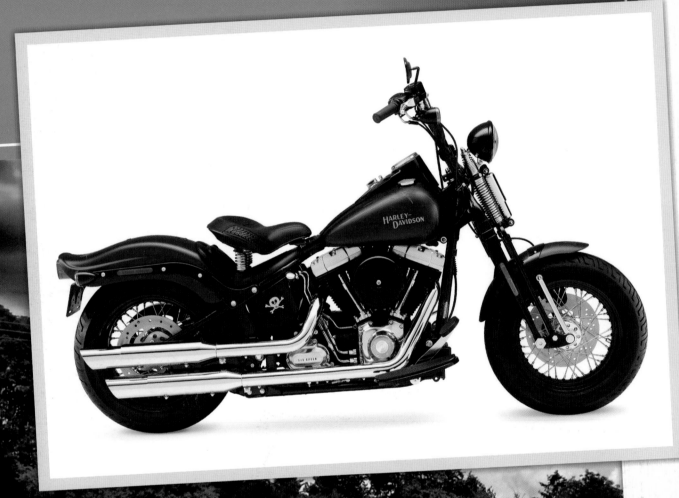

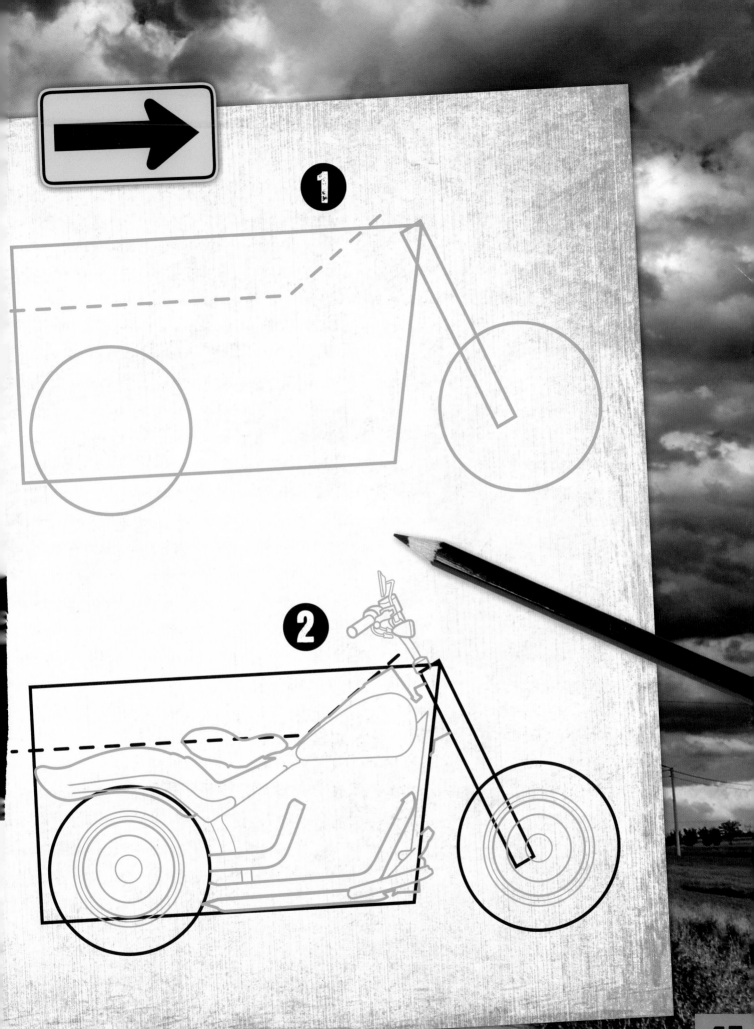

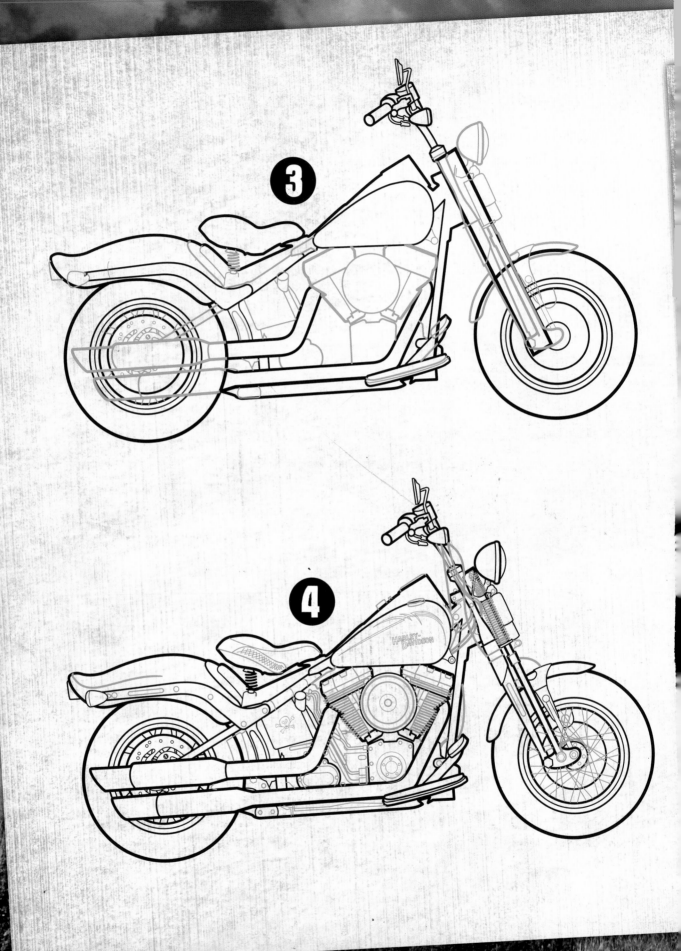

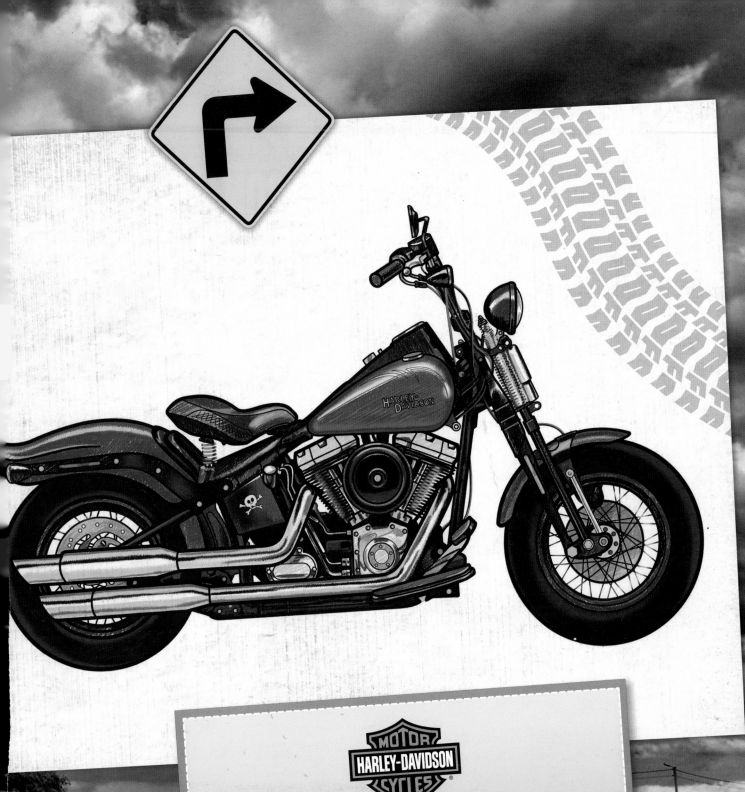

Did you know that there is a Harley-Davidson Museum? Located in Milwaukee, Wisconsin, it houses more than 450 Harley-Davidson motorcycles and hundreds of thousands of artifacts from throughout the company's illustrious history.

POST CARD

PLACE POSTAGE STAMP HERE

FOR CORRESPONDENCE

FOR ADDRESS ONLY

Go ahead–
Enjoy the ride!

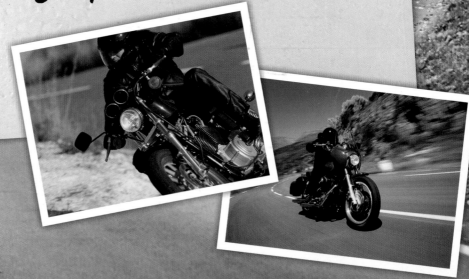